Arctic Notes

and

Prairie Places

ARCTIC NOTES AND PRAIRIE PLACES

The Poetry & Art
of Ferdinando Spina

BAYEUX

ARCTIC NOTES AND PRAIRIE PLACES
Copyright © 2006 by Ferdinando Spina

Published by: Bayeux Arts, Inc., 119 Stratton Crescent SW,
Calgary, Canada T3H 1T7, www.bayeux.com

Library and Archives Canada Cataloguing in Publication

 Spina, Ferdinando, 1949-

 Arctic notes and Prairie places / Ferdinando Spina.

 Poems.

 ISBN 1-896209-87-4

 I. Title.

 PS8637.P46A67 2006 C811'.6 C2006-905616-1

First Printing: October 2006
Printed in Canada

Books published by Bayeux Arts/Gondolier are available at special quantity discounts to use as premiums and sales promotions, or for use in corporate training programs. For more information, please write to Special Sales, Bayeux Arts, Inc., 119 Stratton Crescent SW, Calgary, Canada T3H 1T7.

The publishing activities of Bayeux/Gondolier are supported by the Canada Council for the Arts, the Alberta Foundation for the Arts, and by the Government of Canada through its Book Publishing Industry Development Program.

POEMS

PAINTINGS

SCULPTURES

PHOTOGRAPHS

- Ferdinando Spina

MAJIC MAN

The Majic Man appeared at night
Betwixt the moon and Big Dipper
Very few would join him there
Because large fish and butterflies
Would steal his time and thoughts
And make all others feel unwelcome
With their fleeting flying wings and fins

And when the majic came and went
No one could tell the difference in what was
Or could have been.
But small flowers grew from his back toward the night sky
And small children drew closer to God

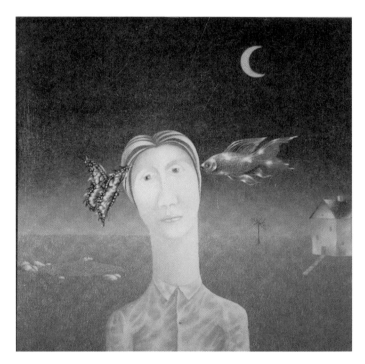

PAINTING:
Fish Fly Butterfly
Oil on Linen
20" X 20"

A NUMBERED KISS

The embrace was close
The lips sublime
Where once were two
One was prime

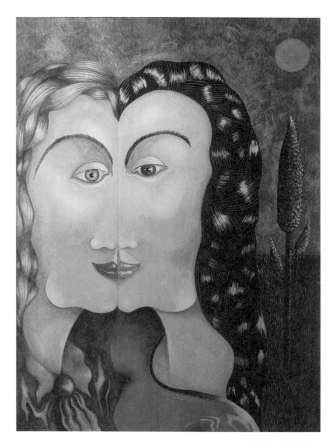

PAINTING:
The Kiss
Water Colour and Acrylic on Paper
13" X 17"

9

NIGHT GAMES

When I turned the corner
Great white buffalo
Wandered the deserted streets
And white Indians danced the minuet
On the roof of the Anglican Church

I made no attempt to make sense of my vision
And accepted it as it was.
Quietly I strided out into the street
And on to the back of a big She White

In turn I was carried through the night air
And into my next vision.
Where people of many minds and ages played night games
Which no one lost or understood
But with each play people on the other side of the world
Made love and killed their children
In full view of God and the Devil

I sometimes wonder about my vision
But now I turn to it in comfort
When reality and the burden of myself
Are too much to bare

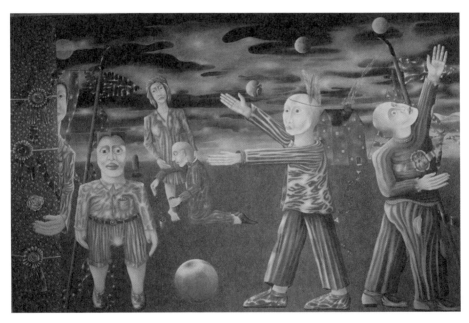

PAINTING:
Night Games
Oil on Linen
7' 6" X 5'

THE LIVES OF MEN AND WOMEN

The men and women of Osyoos gathered
In ways that were both ancient and languid
Gathering for no purpose, their union was purposeful
Lacking meaning they accomplished much.

The earth spun in great orbs about the sun

Blinded by earth's beacon other worlds turned and
Rode the night sky to join with lesser stars.

Unknowingly their lives set the beat of the universe.

A pebble rippled through the Nights Sea
And caused great tidal waves in distant worlds

And when they rested and slept the night smiled her warmth
And man and women who know no better still think all the while
Their lives and sleep and rest are nothing more than that

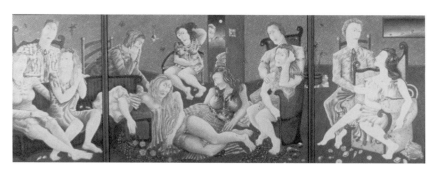

PAINTING:
The Lives Of Men And Women
Oil on Linen (3 Panels)
16' X 5' 6"

13

BATHER BETWIXT

The bather washed
She soothed herself
Her hands ran the length of her leg
Looking to the clouds
They dried her body clean
She now could choose
Either house or both
Free to be blue or red with passion
She ran to one and then the other
And then she bathed again

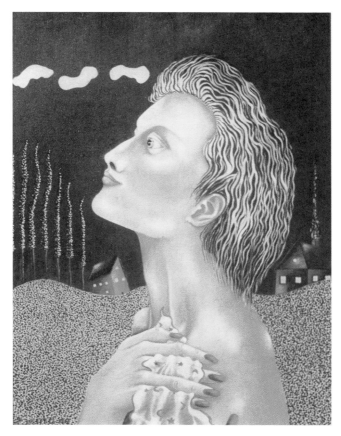

PAINTING:
Bather Betwixt
Oil on Canvas
14" X 18"

MASKS OF THE MILDLY MAD

The party was held in an old wine cellar
Where previously young men had made love to
Older bare foot women

And when the peopled masks began to enter
The young men and women hid behind wine casks
And made love eyes at each other
From across the darkened room.

And as the party drew into the evening
And the light grew golden with sober passion
Men and women began to discard their masks
To show more modest features.

And with that gesture it made me yearn again
To see the masks of the mildly mad
For I know now that I understood and trusted them
far better than those flaccid features of lesser men.

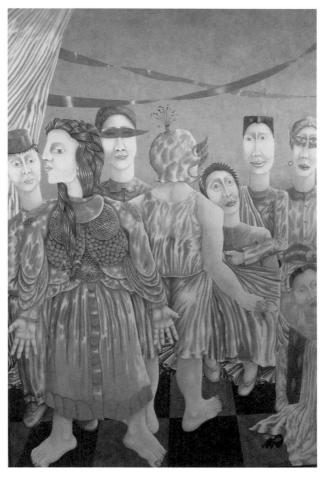

PAINTING:
Masks Of The Mildly Mad
Oil on Linen
5" X 8"

17

THE MAN OF FIRE

I met him on the road to Karomeaus
And in the moonlight he said:
Come to my house
And I will feed you something hot
And when we arrived
He made his dark haired women
Feed me bowls of fire
That burned into my belly

They are there still,
Those bowls of fire
That burn forever deeper in my flesh
And when I speak
Great flames shoot out
And burn ideas
Onto open brains
That listen
In hopes of
Catching fire too.

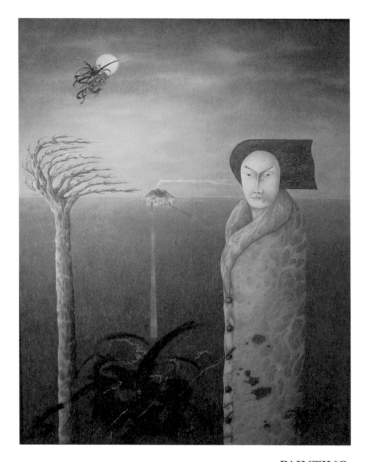

PAINTING:
Chinese Man Blowing In The Wind
Oil on Linen
3' X 4'

LOVERS LEAPING - THIS WILD AND AIRY FLIGHT

In their seeming suicide
They sailed above the earth
Without regard for gravity
They grasped the grip of love

Forever light and airy

And when pointed out by people
Behind the wall of sane and sober thought
They smiled and dropped flowers
On their heads
And yelled
Come join us
On this wild and airy flight
Come join us
On this wild and airy flight

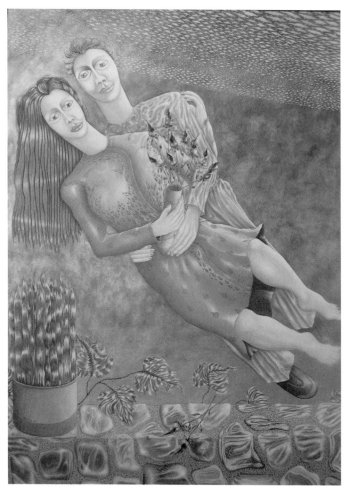

PAINTING:
Lovers Leaping
Oil on Linen
5' X 8'

THE GATHERING WELCOME - HUNGER FOR THE ARRIVAL

Waiting with little regard for time or place
They lingered with hunger for the arrival
Those that worked ceased
Those that had born children minded them and accompanied them
Payments and debts
Promises and broken promises were discussed and settled
All in preparation for the arrival

The acid green sky lay in wait
The arrival came and went……
The people being spent, turned and also went
Satisfied that their hunger was gone,
The gathered welcome complete
They began the wait anew
Larger tastier treats were soon to ensue
All was well
At least for now.

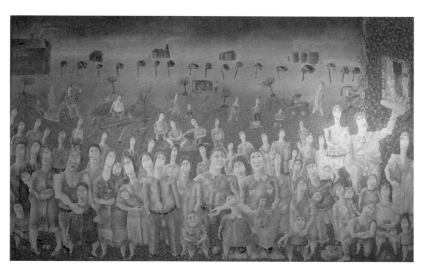

PAINTING:
The Gathering Welcome
Oil on Linen
6' X 4'

THE EMBRACE

A flowered and leafy past
Now chequered with substance too heavy to bear

And yet in this there is bonding, a merging of all that
There is and was and will ever be.

In spite of the past the present exists, against all odds.
The future still a possibility.

Our lives are sometimes harsh but tempered with the solace and union with
others we made due and embrace the world as it is and dream of what it
could become.

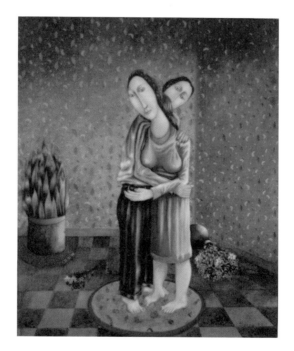

PAINTING:
The Embrace
Oil on Canvas
16" X 20"

THE RENDEZVOUS

The rendezvous was cool, and sweet
The flowers so divine.

Yet in all of this
The circle that was their lives
continued to unwind.

Oh sorry, sorry state.
Their sweetness to depart.
What will be tomorrow at this place
Is not for those of heart.

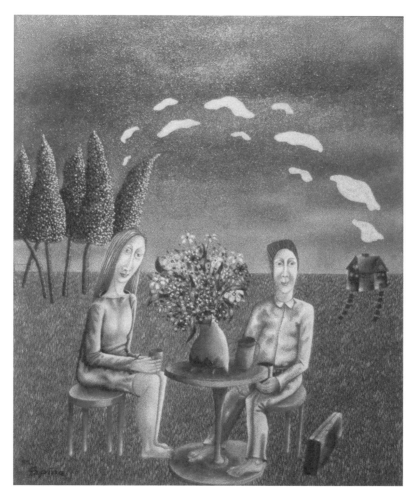

PAINTING:
Rendezvous
Oil on Canvas
16" X 20"

BEFORE THE DAWN

On the prairie, beyond all knowledge and ignorance,
He waits daily for the dawn.

In the stillness he prepares to wake the sun.

Without effort or thought, conceived but not contrived,
He rolls the orb within his palms, and prepares to pitch.

In the quiet calm before the light, he slings his sphere,
And wakes the sun into its flight across the sky.

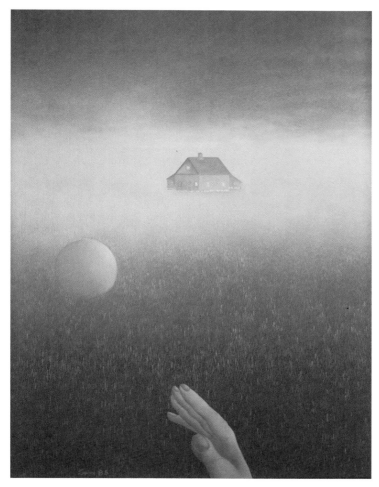

PAINTING:
Pre-dawn Prairie Pitch
Oil on Linen
16" X 20"

HOUSE SLEEP

In the evening as the sun sets
People take to their beds and sleep.

The houses standing all the while
Nestle to the treetops to rest and dream,
And prepare for the coming of a new dawn,
Where they will stand again in nurture and support,
And house their human herds,
In wakefulness and watchfulness,
Like large, warm nannies.

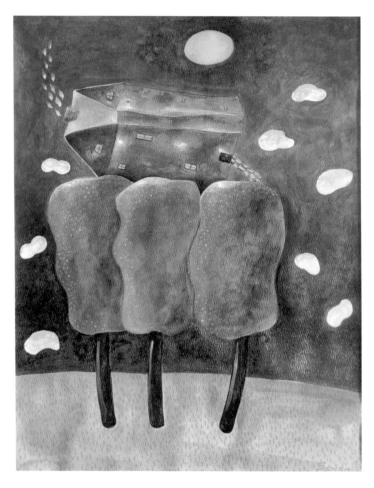

PAINTING:
Tree House
Acrylic and Water Colour on Paper
11" X 15"

FIVE TREES – FIVE CLOUDS

Five trees
Five clouds
What is its meaning?
A man
A woman
Children
A house
A life
What is its meaning?

Note: People are always searching for meaning in life. Perhaps it just is, much like a tree or clouds. We can interpret things, or give meaning to anything, even our lives, our work, our relationships, but does that change anything? Invariably we give our own life meaning by how we exist.

Would our lives change if we attribute meaning to them? Would we do things differently? I don't know, perhaps, perhaps not. Do we need to name things for them to exist? "Yes and no". Perhaps "humans" need to make things more clear. We don't believe it until we name it or it's on T.V.

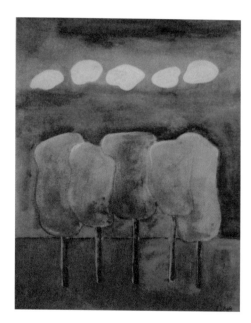

PAINTING:
Five Trees Five Clouds
Water Colour on Paper
9" X 12"

WOMAN WITH CHILD OVER BLUE GRASS

Woman with child
Over blue grass
Hard as nails
Metal Ma Ma
Biker Babe – splitting her side
Bright blue blades
Riding her high
Waiting for a ride
Upturned lips
Whispering softly
Ride me uptown
Ride me uptown
Ride me to the Lido De Lux.

SCULPTURE:
Woman With Child Over Blue Grass
Wood and Metal
9" X 14"

AN ODE AND VOYAGE TO AMSTERDAM

I am on my way
Amsterdam city of water
Venice of the north
Dutch, Colder more austere
Still beautiful
Home to Vincent and Theo
Anne Frank
Rembrandt
The Dam Square
1928 Olympics
Sex shops
Tulips
Sweet Amsterdam
Where I learned to draw faces
With Dominique
A small Chinese man
Long since disappeared
Who even now inhabits
The far corners of my thoughts
And the disarray that passes as my mind
Cool, cold Amsterdam
I will warm when I walk your strasses and gratchs
And harbor thoughts
That will last another twenty-five years
Thank you Amsterdam for
Adding to the substance
Of that which is Me.

Note: I learned to draw by following a street artist around Amsterdam and watching him draw portraits. In a little while I too was selling my portraits. The artist I followed was known as Dominique.

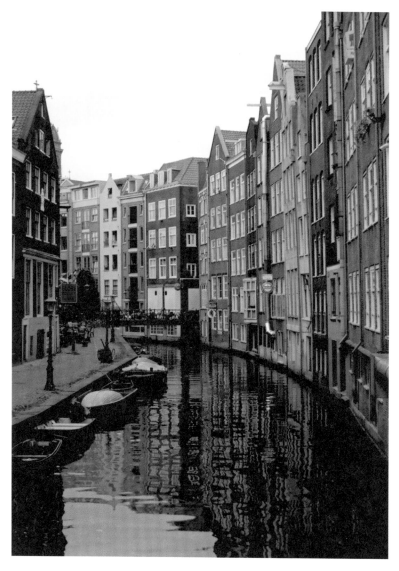

PHOTO:
Amsterdam 2002

THE LINE UP

Women waiting
Manikin madness
Who knows what lurks below?
That Dutch interior?
Stoic stillness
In tight ass threads
An organic wasteland
Like frozen dinners
On a refrigerator rack
Almost delicious
But not quite

Note: "Dutch Interior" alludes to a painting by Miro with the same title.

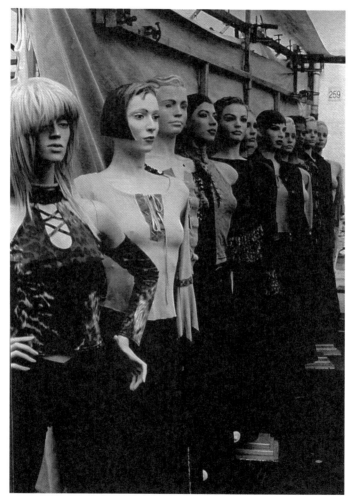

PHOTO:
Amsterdam Market 2002

TIVOLI

Garden of a Thousand streams
H_2O on tap
Spouting from every breast
Pouting lips
Gargoyles
Maidens
Beasts
A cascading cavorting of currents
Caressing your ears
Careening and babbling
Brooking no noise
Soothing
Making
You
Whole
Wishing
You
Were
A water Nymph
Neptune or Trident
Opulent
Wet
Serene
Tivoli
More opulent
Than Trevi
Awash
In moist and mossy
Munificence

Note: Tivoli Gardens is a water park with over 1000 fountains

40

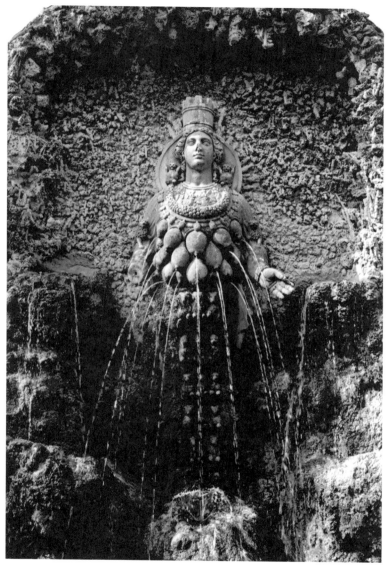

PHOTO:
Tivoli Gardens Outside Rome 2002

41

ODE TO MY COUNTRY CANADA

Country of lakes
Mother of mountains
Canadian Shield
Atlantic
Pacific
Snow
Forests
Tundra
The Arctic
French
English
Native
All peoples
Beaver, buffalo, elk
Salmon
The Fraser
The Mackenzie
The St. Lawrence.
Intertwined between:
Persons, land, water, sky.
Canada, wefts and warps its way
From end to end
Never ending
Always lending itself
To its sons and daughters
Who stand upon its shores and in between
True to the land and it to them
Canadians

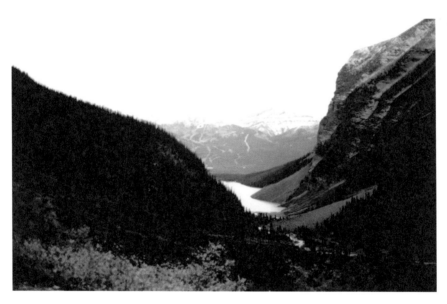

PHOTO:
Canadian Rockies

BIRTH OF A NATION

Small birds played the open sky
Fisherman hooked large trout
Mountains rose high in the west
Canada was born on such a day.

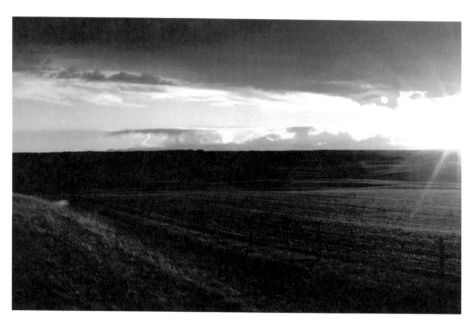

PHOTO:
Alberta Landscape 2003

FLY WITH ME AWAY

Dream me in the night
Dream me in the day
Dream me as a bird
And fly with me away.

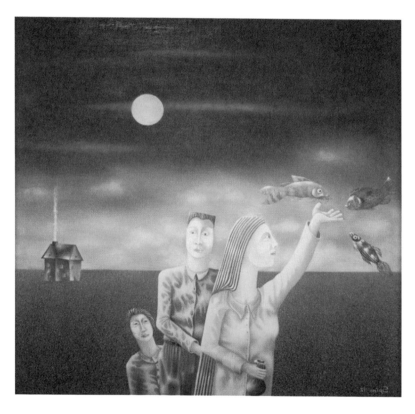

PAINTING:
Fantasy Fish Fly
18" x 18"

VENICE OF THE BLUE LIGHT

Blue light
Green Square
Nobel Venice
Venice disserted
Steamy nights in Venice
Arches in Venice
Home to Tintorettos
Colorful tints
Tiepolos
Titians and Veronese
Graffiti on ancient walls
Streets without banality
Full of past and present
Canals caressing all
Waterways to new and old
Destinations wind their way
Veins of Venice
Lifeblood
City of the festival
City of endless beauty
Receptacle and residue of mirth long past
Commercialized yet so sweet
I feel my ancestors talking gently in my minds ear
Stay, stay, stay awhile
Stay a little longer with me
For I am lonely for you
For your devotion and adulation
Sweet Street Whore, Fairy Princess!
Who can tell?
Who cares?
I will always love you
Venice

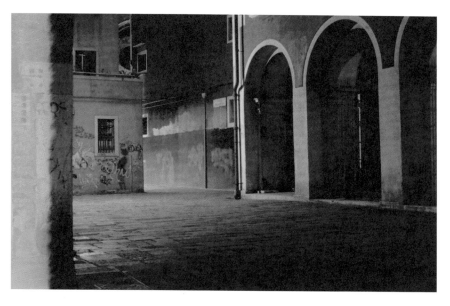

PHOTO:
Venice Plaza 2002

VENICE THE SEDUCTRESS

Venice
Home of emerald canals
Warn ensconcing Venice
Casa de Vivaldi
The Doge
City State
Bridge of sighs
Rialto Bridge
The lido
St Marks and its most perfect space
Where men and women
Not dwarfed by glass behemoths
Feel more whole, more human
Venice, so like Amsterdam
Yet so different
Most beautiful most sensual of cities
Golden domes of St Marks
Call out to you
As does all of Venice
In her splendor
She whispers
Come, come, and come to me.
Let me seduce you.
Let me be your mistress
Let me be your love
Let me be your
Venice.

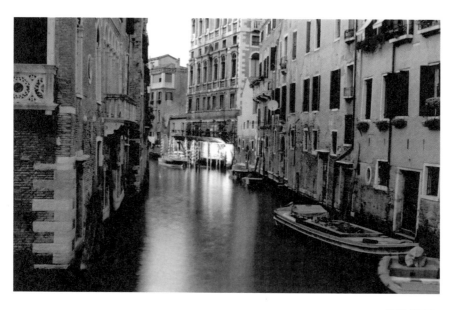

PHOTO:
Venice 2002

THE LEGEND OF THE BLACK BEAUTIES
AND THEIR MAGIC OF THE DAY

Sleek black whales
Skim the deep waters of the bay.
Women of dark beauty
Ride their backs.
Unable to hold on fully,
They sometimes slide the full length of their bodies
And ride the tails and flukes,
Only to flip from their world to ours.

Sometimes in the early hours
They are found washed ashore naked,
Tangled in their cloak of long languid locks.
Warmed and fed they return to their ritual and rite of passage from this
world to the next.
In this way both worlds are fed, refreshed and replenished,
From day to day and night to night

It is said that should the beauties refrain their rides and rites
Both worlds would cease
And the universe be thrown to chaos.

So ride and rail against the tides deep beauties
Brook the backs of whales
And keep the magic of the day replenished
On the morrow.

Note: This poem was written with the image of Long Beach, Vancouver Island in mind. As a World Heritage Site it affords much opportunity to see whales and wildlife in a pristine land and waterscape. After numerous visits there, it has become one of my favorite places to be. Long Beach has always struck me as a magical place, a Canadian place.

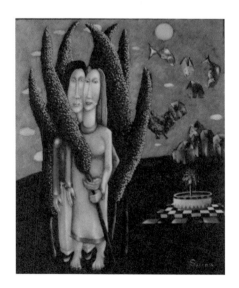

PAINTING:
Oil on Canvas
16" x 20"

CARVER

White wind
Wasteland
Carver carving bone ivory stone
A dark Inuit mound on white landscape
Emerging
A day later
Stone seal and hunter in hand
Carved and shiny
Completed in round opulant curves
Romanesque in beauty and form
Simplicity in stone
Delivered in cupped hand
Botticelli with a half shell
Inuit intentions
Inuit intuition
A rounded Rubens
With spear and seal

Note: I have often seen Inuit carvers carve in 40 below temperatures with Arctic winds blowing all around them. Working all day they end up producing a sculptural work to sell and feed their families.

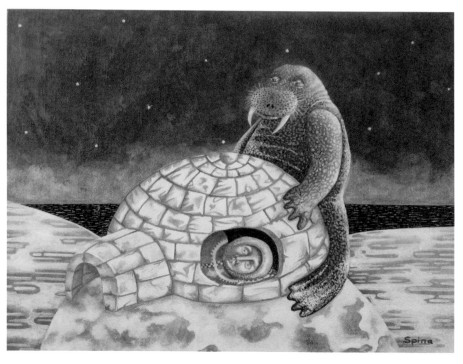

PAINTING:
Inuit Dreaming of Hunting Walrus
Acrylic on Board
14" x 11"
(this painting depicts inuit thoughts and dreams
and a subject carvers would render into stone)

MYTH OF MOUNT PELLY

Giant Inuit
Sleeping
Slumbering
Somniferous
Reclining and resolute
Huge mounds
Punctuating the Arctic
Natural Inuksuks
Unformed by human hands
Standing
Sentinel like
Gates
To the top of the world
Reality cloaked in
Myth

Note: Outside Cambridge bay on Victoria Island in the Canadian Arctic three large mounds can be seen from miles around from the relatively flat land that surrounds these mounds. The largest of these mounds is known as Mt. Pelly and is thought of as male in nature by virtue of being the largest. The other two mounds are named Lady Pelly and Baby Pelly by the local Inuit populations. Baby Pelly is located between the larger mounds much as a child between parents.

The Inuit believe that Giant Inuit ancestors roamed the Arctic at one time and when there was lack of food they lay down and died. The three mounds are the remains of this family of giants.

The Mount Pelly area is a wonderful place to view birds, various plants, flowers and musk ox.

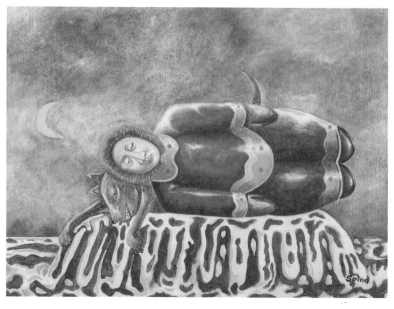

PAINTING:
Giant Inuit Sleeping on Mt Pelly
Acrylic on Board
14" x 11"

THE ARCTIC EDGE

Clean crisp glacial cold
Benumbed isolation
Great expanses
Beautiful bleakness
Stark raw reality
Served on edge
With a side order of blinding whiteness
Of ice
Of snow
Of wind
Edge of the world
Standing on ice
Thin ice
Ice slipping away
Quietly in caribou slippers
Life balanced in death
Each taking turns
Leading
Being led
Snow that saves
Snow that kills
Snow that hides
Snow that igloos you in her warm caress
Away from her bitter brer
Blowing with outside rage
Roughed with calloused cold
A razors edge
Cutting biting with impartial cold
Egalitarian in every sense
An ulo cut
Warm red blood on snowy ice
Both beautiful and full of its own beast.

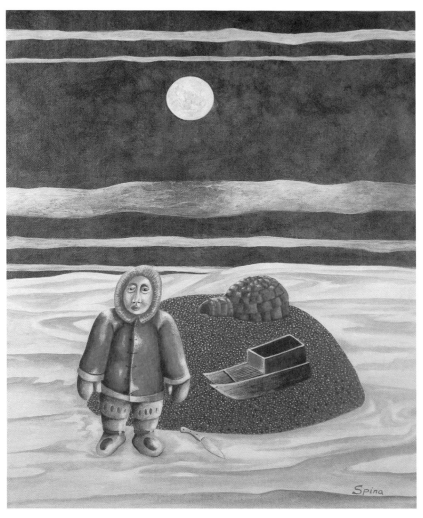

PAINTING:
Red Inuit with Sled and Knife
Acrylic on Board, 12" x 15"

Note: An ulo is a half moon Inuit knife with a "T" handle used to cut meat and scrape hides.

ARCTIC STONE (SHAMAN ON ICE)

Stoic
Solitary
Still
Stone
Shaman

Green soapstone slab
Starring open eyed
In you
Beyond You
More than stone
In a spirit of its own
Living breathing stone sighs
Bellowing winds
Unseen by most
It lives on the edge
Arctic like
Between this world and the next

Note: I have seen Inuit on iced flows just standing there, stone-like, on the edge, not moving, like a soapstone carving. This poem comes from those visual punctuations in the Arctic. Sometimes I've looked back and after seemingly standing there forever the figures were gone and I could not think of where they had gone as I searched over the expanse of ice and snow. I sometimes think that those that vanished were shamans.

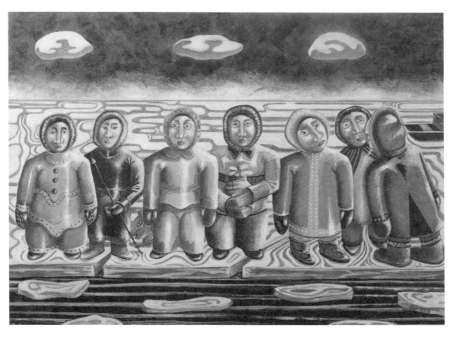

PAINTING:
Inuit on Edge
Acrylic on Board
16" x 12"

INUIT SLEDS

Sleds
Lumbering lumber
Sliding, skimming over ice
Prepared and primed sleds
Food and gas sleds
Tied and straight laced sleds
We mean business sleds
Square jawed sleds
Prepared to ride the snow and ice for weeks on end sleds
Fishing hunting soapstone filled sleds

Manned by resolute riders on plastic runner strips
They jump and slide over blue and white ground
Skating they leap headlong into open ocean leads
Connecting to the other side
The creaking wood resounds relief

Inuit with frost bite
Biting winds
Living solitudes
Riding iron machines and wood
Senses cut sharp
Ulo like
They move and cut straight lines
With these sleds
To destinations
Long determined before their birth

PAINTING:
Bathurst Inlet with Sleds
Acrylic on Canvas Board
14" x 11"

ICE CHARD

Vast expanse of tundra
Ice and snow
Open seas
At times
Harbouring an oasis of warmth
Where animals and men
Rest and sup

The Arctic
Enclave of whiteness
Eager men cut from the same hue
Look out to the future

Brown and red men
Here before time
Blink and all that they discern is gone
Replaced by another whiteness
Perhaps more menacing than that whiteness known

A crack and shift in the un-carved block
Makes all uneasy and bereft of foot

An ice chard moving at high velocity
Aimed at your heart

Note: Sometimes in the dead of winter warm currents open up the ice pack into a warm oasis where all types of animals and humans go for food and warmth.

This poem was written with the underlying reality of the great development and exploration now proceeding in the Arctic. As with many things there is good and bad associated with this. For most it will be a shift or crack in their reality and for some a chard moving in a high velocity cutting and forever altering.

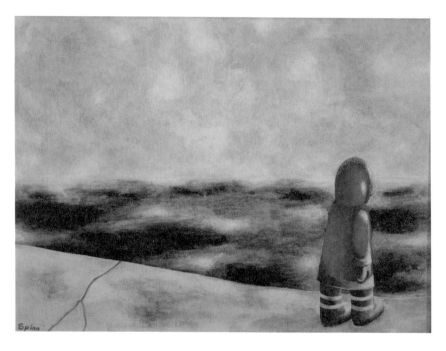

PAINTING:
Red Inuit on Edge in White Landscape
Acrylic on Board
14" x 11"

LEO THE CARVER AND HIS HEE HEE HEE HEE

Gjoa Haven Leo
Fat round Leo
Big headed Leo
Leo with the carvers itch
Leo who laughs with a Hee Hee Hee
Leo who told me once that he jumps leads and sometimes doesn't make it to
the other side
Says he looses his skidoo and sled
But always laughs and says he's too big and round to sink
"I float like fat" he says and quickly adds his Hee Hee Hee
Leo who strokes his belly lovingly and says it keeps him alive
In water and on land
And when there is no food
He caresses it like an old friend
Who is always there for him
Leo who carved me a half bird and half man
A transformation figure not unlike himself
Big in body
Big in head
Leo the rounder softer Arctic
Fat of the land Leo
Land O Leo
Big bellied smiling Leo
Arctic Buddha Leo
Leo of the Hee Hee Hee

Note: Leads are open water between ice flows or land. Sometimes the Inuit try and make it across this open water
with sleds and skidoos by gathering as much speed as possible before they hit water. Many Inuit have lost their
lives trying to make it across these leads. My friend Leo laughs in the face of these leads saying his fat belly keeps
him afloat if he doesn't make it. In this way Leo has cheated death, where thinner and more agile Inuit have
sometimes not been so lucky.

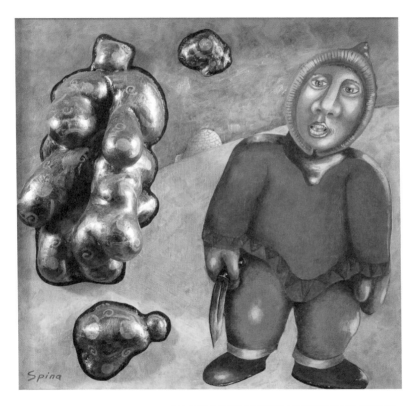

PART SCULPTURE PART PAINTING:
Inuit Encountering the Spirit of the Great Unknown
On Wood Panel
12" x 12"

SATURDAY MORNING IN GJOA HAVEN

In the Arctic stillness
The Arctic calm
God sleeps
Gjoa Haven sleeps

Eventually children wake
And on the streets of Gjoa Haven
Thinking they are Joseph Tootoo
Play road Hockey

Dogs bark in a never ending stream of canine calamity
Headed always by a baritone bark more penetrating than the rest
It is a concerted effort perhaps unknowingly, perhaps not, to wake God and
the rest of us

In so doing what they do best they succeed in
Shaking the earth
Waking God
And introducing Saturday morning to the rest of us

Note: A comment on one of the many Saturday mornings spent in Gjoa Haven on King William Island. Gjoa Haven is on the path of the North West Passage and a place where northern explorers had laid anchor.

PAINTING:
Gjoa Haven by the Bay on King William Island
Acrylic on Canvas Board
16" x 12"

A DAY WELL FASHIONED

Women like ripe fruit
Waiting to be picked
In opulent orchards

They wait for roughly hewn suitors
Who climb their bushes
Caress their limbs
Appeal their shiny skins

Savouring their succulence
Both suitor and suited
Shine in satisfaction
For a day well fashioned
And fruit well rationed

Note: This poem was written in the Arctic while thinking of ripe fruit. I did a sketch and later a painting while holding a visual picture of the above poem in my head.

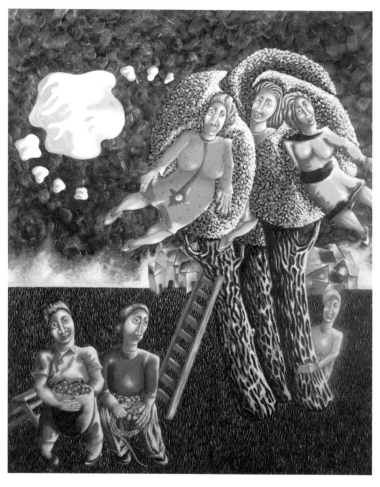

PAINTING:
A Day Well Fashioned
Acrylic on Canvas
16" x 20"

THE HUNT

Steel skidoos
Dogs and sleds
Great caribou herds
Moving as one
A chase
To the open sea
Trapped
Felled by arrows spears and bolas
And now by rifles
A killing cull
A dance of red on white
Caribou silently screaming their pain on dead ears and hungry bellies
Deep cadmium red
Washed on titanium white
Restless and ageless
Cruel
Necessary
An unspoken agreement between Inuit and caribou
Death on ice
Sustaining life in icy huts
And wooden sheds

Note: This poem was written from stories told by the Inuit to this writer.

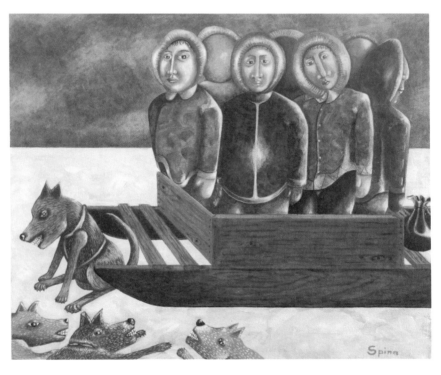

PAINTING:
Inuit Before the Hunt
Acrylic on Board
14" x 12"

ISLANDS IN THE GULF

Islands in the gulf
Sentinels of earth
Mounds on an ice blue wash

With houses and trees
People and dogs
They stand since before time
Before the Indians
Before their totems
Coloured woods on solitary mounds

Witnesses, observers to all that was
All that will be
First to know what the ocean brine brings
To what the ocean sings
Viewers in a mellifluous soup

Islands that feed our eyes
Fill our nostrils
Make our skin soft

We live and ride their backs
And play among their rocks and trees and bays

Island impulses
Far from mainland madness
And melancholy mists

PAINTING:
Gulf Island People
Acrylic on Strathmore Board
15" x 10"

TREE CROSSINGS

Trees are stationary for the most part
But don't you think they would like to move sometime
And if they moved
Would they take boats to go from island to island continent to continent
If trees did this all the timed would it seem weird or become common place
and normal
Is the difference between weirdness and normal just a matter of frequency?

Now more and more I see trees on the horizon
And I plan to ask these questions once they arrive

PAINTING:
Tree Crossings
Acrylic on Canvas
16" x 20"

QUESTIONS OF A BOAT ON A RIDGE

Are we boats out of water?
Caught on sand ridges
Do we wait for a tide that never comes?
Do we struggle to leave the ridge?
Or do we enjoy the view

Do we ride the river?
Without direction
Arriving when we get there
Or do we struggle
Expending energy
Toward the direction and destination we think we should journey
Only to get stuck on sand ridges waiting for the torpor tides to arrive

I know now I will ask these questions of the next boat I see caught in a
waterless web, stuck on grievous gravel

PAINTING:
Boat on Sandbar
Acrylic on Canvas
16" x 20"

PRAIRIE HOUSES AND FIELDS

Houses on the prairie
Solitary
Without company
Without sympathy
Without fellowship, fraternity
Together but apart
Canola compromise
A grainy existence
On an ancient buffalo ground

PAINTING:
Prairie Houses

CANADIAN LOVE CANOE

Small
Compact
One man
One woman
Holding two
Made for one
Watercress
Caress
Callowed contentment
With a lilly twist
Entwined lovers
On a briny bent

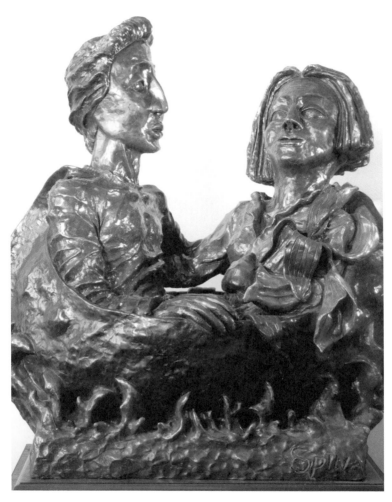

SCULPTURE:
Canadian Love Canoe
Bronze

PRAIRIE LANDSCAPE

Landscape
Patterns on the earth
Prairie
Farmland
Resilient
Reliant
Reluctant at times to
Release
Its nourishment

A chequered past
Saturated in buffalo blood and
Settlers' laments
Railing against all odds
Still fertile
Still here

Land that fills the eye and
Beckons the belly
A Canadian blanket covering our
Collective consciousness.

PAINTING:
Prairie Landscape
Acrylic on Board
12" x 9"

BUFFALO DREAMS AND PRAIRIE NIGHTS

Buffalo
As far as the eye can see
Sixty, one hundred million, who knows?
The prairie, the foothills the forests.
All here, where I am living, standing, sleeping.
I feel the ghosts
I see them in my dreams
Killed by my ancestors
Made to jump at Head Smashed In
By more distant relatives.
They inhabit my mind, my soul,
Like one hundred million thoughts that have no rest.
It is time I think for the White Buffalo to come.
And talk to us of peace and gentler ways

Note: The Natives say that when a white buffalo is born it will usher in a time of peace for the world. I have heard that not too long ago a white buffalo was born in the USA.

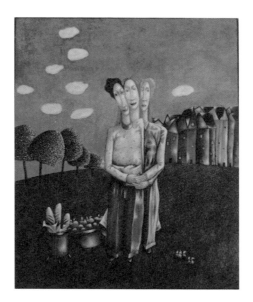

PAINTING:
Oil on Canvas
16" x 20"